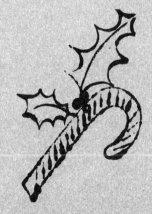

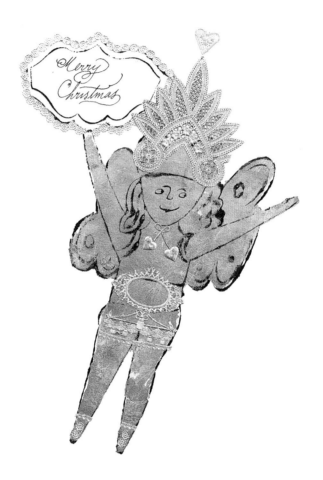

HARRY N. ABRAMS, INC., PUBLISHERS

Greetings from Andy (Warhol)

Christmas at Tiffany's

by John Loring
Illustrations by Andy Warhol

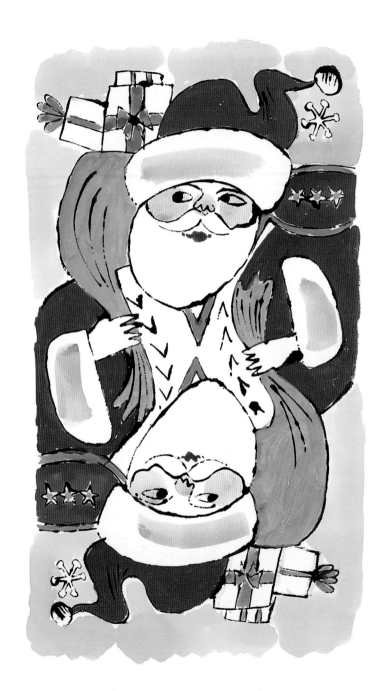

Contents

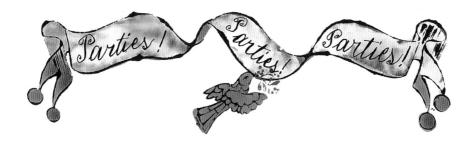

"Everything he did was a big surprise and charming."
—Arthur Elias from *Pre-Pop Warhol*

ndy Warhol called on America's reigning magician of window display, Gene Moore, a few months before Moore moved from Bonwit Teller to Bonwit's next-door neighbor on Fifth Avenue, Tiffany & Co. Never one to overlook a good opportunity, Moore put Warhol to work. In his memoir, *My Time at Tiffany's,* Moore recounts: "In July 1955, just before my work began at Tiffany's, I made some wooden fences, he covered them with graffiti. They were fun, full of a childish playfulness. . . . He was called 'Raggedy Andy,' not because his work was sloppy, but because of his appearance." A few months later, Moore introduced Warhol to Tiffany & Co. The first Warhol Christmas card, *Butterfly Tree,* appeared in Tiffany's 1956 catalogue over the caption "Gay cards with Christmas Spirit." The Warhol-Tiffany card adventure continued for seven

more years, ending with *Holly and Fruit Star* in the 1962 greeting card catalogue.

Andy had developed his light and blotchy "printed" drawing style while a nineteen-year-old student at the Carnegie Institute of Technology in his hometown of Pittsburgh, where he also made his first Christmas cards. His influences were multiple: part Paul Klee's ethereal and poetic transferred drawings; part Ben Shahn's blunt variable-line drawings; part Alexander Calder's playful splotches and spirals; part 1940s television graininess, with a bit of his own "un-cut cut-out paper dolls" collection thrown in for a dose of the simplistic and vernacular.

Warhol began with pencil drawings on paper, which (to avoid any high-art implication of his fine draftsmanship) he would cover with water-resistant paper and trace with a leaky old fountain pen. Then he offset the wet-ink drawing onto watercolor paper, pressing the sheets together to make the ink splotch on the offset image. (Or, for printed effects, he carved stamps from large art-gum erasers.) The resulting printed drawings were colored—frequently by others—in a loose, childlike manner that paid very little attention to keeping the colors inside the lines.

When he went to see Gene Moore in 1955, he had just begun to draw
I. Miller's shoe ads for publication in the *New York Times.* The ads, with their
whimsically decorated shoes, had a witty, sophisticated, cardlike quality to them.
They earned him an Art Directors Club Award for Distinctive Merit in 1956 and
a second such award, along with an Art Directors Club Medal, in 1957. By winter
1957, he was in the book *1,000 New York Names and Where to Drop Them.*

Once, Warhol took Gene Moore to meet architect Philip Johnson. Johnson
gave Moore the job of designing the holiday display in front of the new Seagram
Building on Park Avenue. Moore lit twin forests of pine trees with tiny lights
(the first time that had been done). Warhol did *Tree of Stars* for both Tiffany's
and Moore.

In *The Philosophy of Andy Warhol,* Warhol noted: "That was my life in
the '50s: greeting cards and watercolors and now and then a coffee house poetry
reading." For Andy the illustrator, anything he was fond of
could become material for a card. This included fruit,
like the fruit he sold off a truck as a child to help
his poor family's finances; angels, like the
"angel in the sky" his classmate and

merry christmas to you

childhood friend Philip Pearlstein compared him to; stars, because he was always "star struck"; butterflies, like the paper butterfly he had made for Greta Garbo when he couldn't think of anything to say to her; or roses, like the silver vermeil roses from Tiffany & Co. that he sent art directors at Christmas time. And there were shoes filled with holly. Shoes made a nice Christmas image. St. Nicholas, as legend has it, threw gold coins in the window of three sisters who needed dowries to marry; the gold coins landed in their shoes (which also explains Christmas stockings).

Andy added what a friend called "his mother's distinctive and loopy" handwriting to his images, after finding he was not able to "print" his own writing without ending up with a mirror image. That also helped keep his art away from the too-personal; helped him maintain that poetic distance he always insisted on. He spoke in clichés, benign opinions overexposed in print and conversation: "Gosh! That's great! Wow! Oh, that's so great!" "Great" was his favorite—so noncommittal and, again, so impersonal.

The poetry of life's little surface charms never escaped Andy's notice, and a Warhol anthology of these pleasures greets us in his cards for Christmas. They are one of the great delights of twentieth-century graphic art, and Tiffany's is proud to be associated with them. In fact, we think "They're great!"

John Loring

10

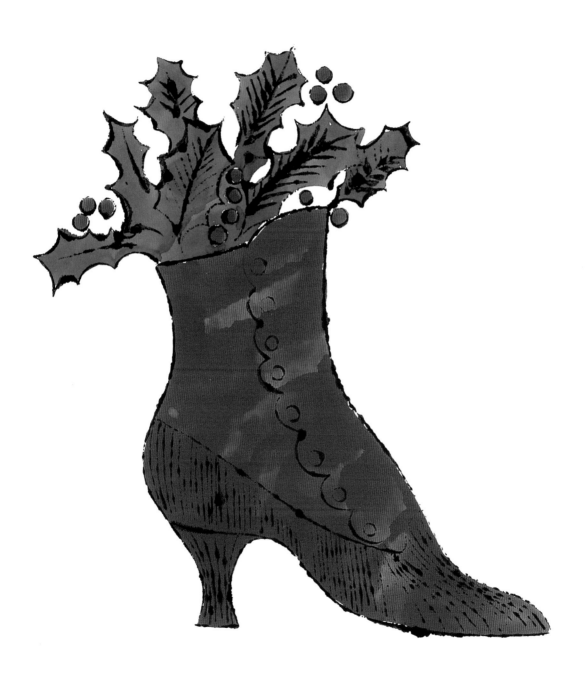

Merry

Christmas

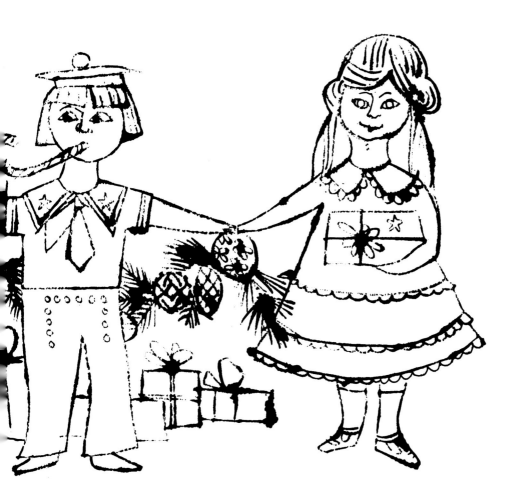

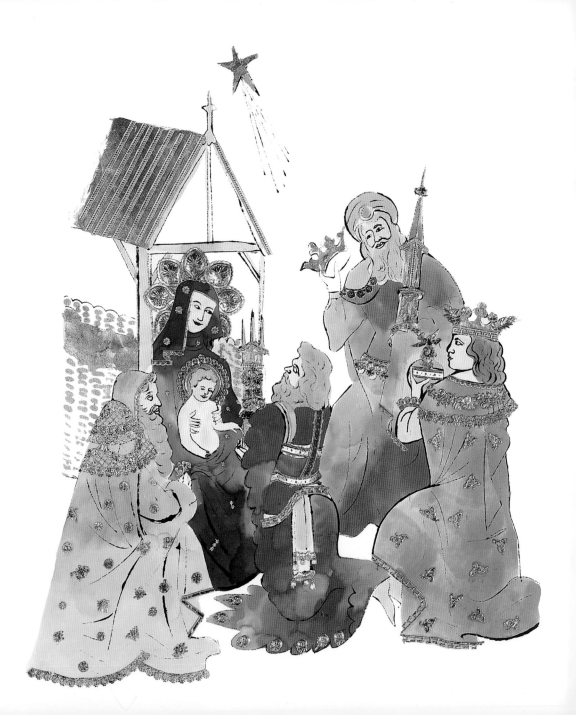

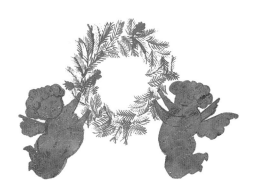

At the stroke of midnight, on Christmas Eve in Manhattan, I ring Andy's bell. Julia Warhola opens the door and smiles broadly when she sees me. After embraces I give her an Austrian tin music box. Upon opening it, carillons of "Silent Night" fill the crisp air. Andy's face appears at the door—two snowflakes land on his nose. For him I have a crystal bottle of black truffle oil with a card that reads:

> *Dearest Andy... lord of New York ... will you be mine?*
> *Merry Christmas 1969*
> *Your ambrosial, crystallized Violet*

We all sing "Holy Night . . . all is calm . . . all is bright" and we giggle. Silver ginger-man cookies are found in the music box. Andy vanishes and comes back with a round canvas portrait of Marilyn Monroe. "For you, Ultra, from a star to another star, on this starry night."

My my my . . . it was a very merry merry Christmas!

Ultra Violet
April 2004

" Right after midnight it was everybody grabbing their coats, they couldn't wait to go on to the next party. "

The Andy Warhol Diaries, December 31, 1976

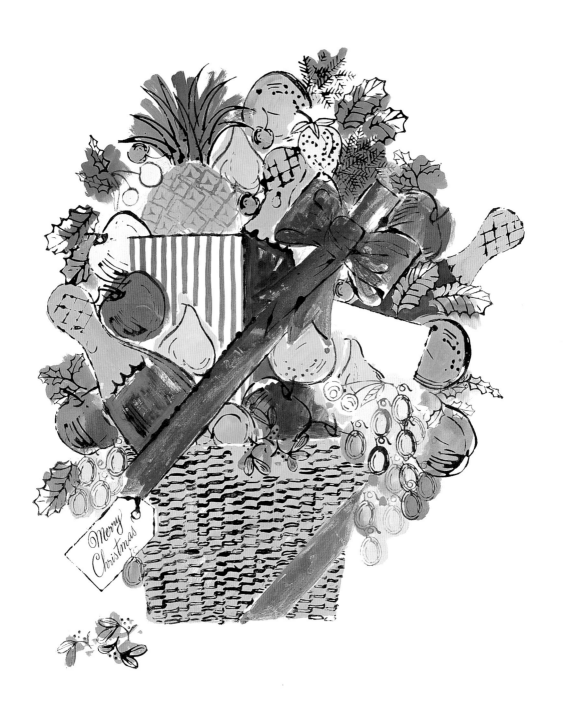

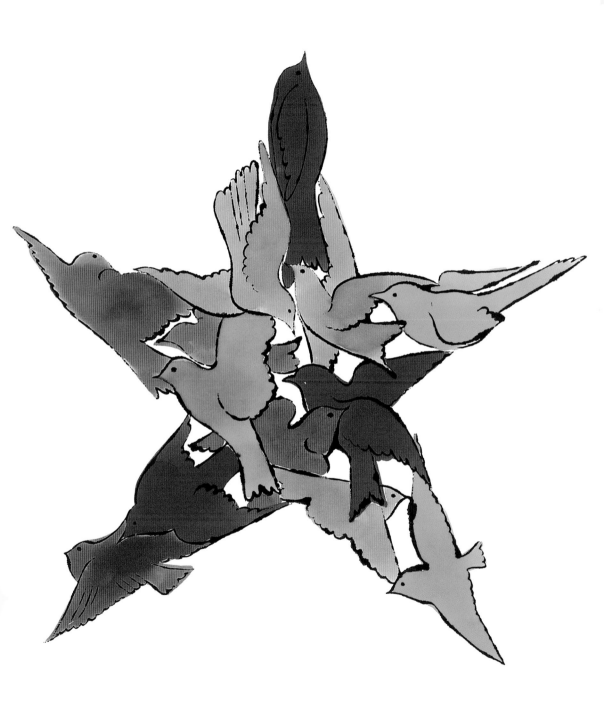

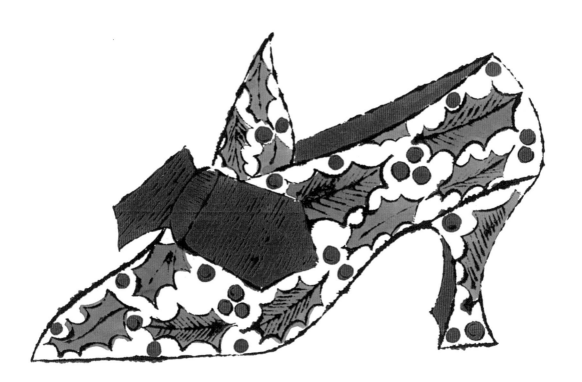

". . . and then it started to snow and the flakes were so big and beautiful but before I could get to the window with my camera it had stopped.**"**

The Andy Warhol Diaries, December 23, 1980

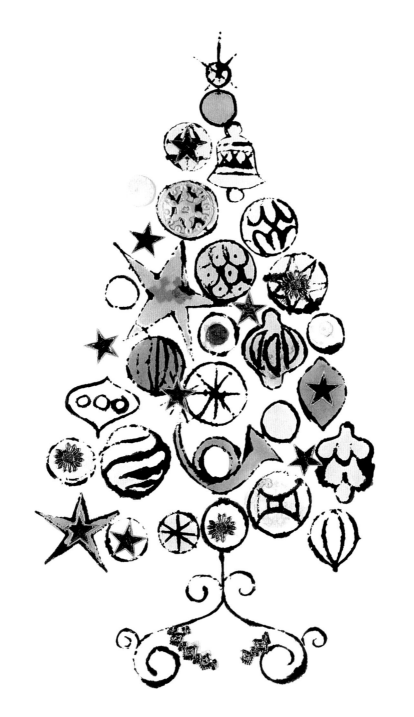

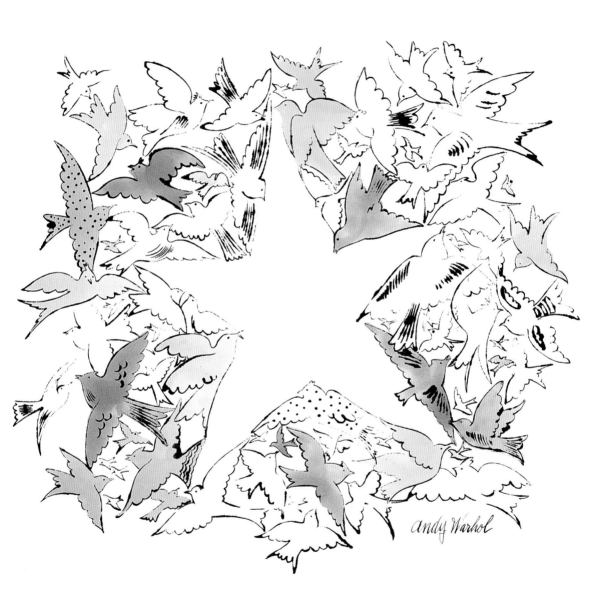

"Tried to wrap presents . . . I guess I took all day . . . went through a lot of fuzzy paper."

The Andy Warhol Diaries, December 25, 1983

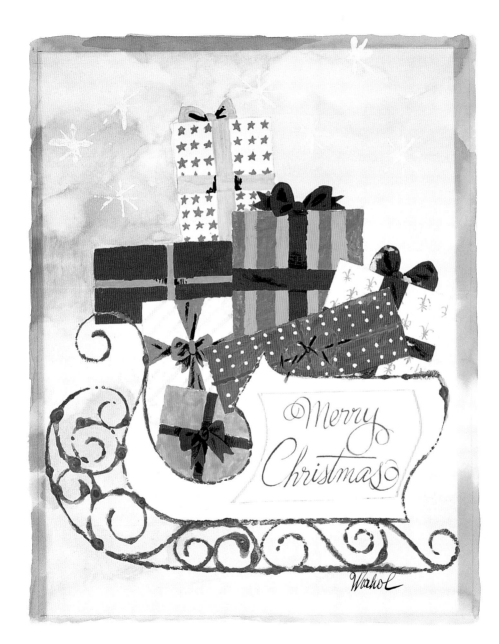

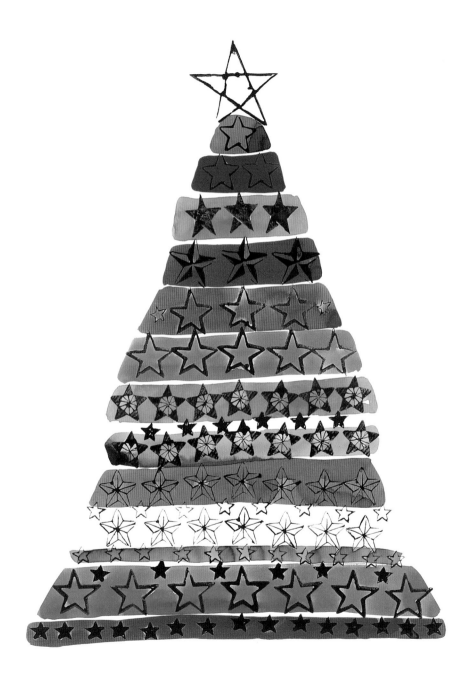

"And the bigger the box, the less present ..."

The Andy Warhol Diaries, December 25, 1983

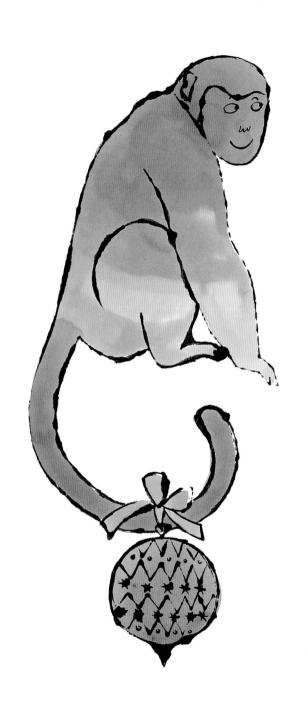

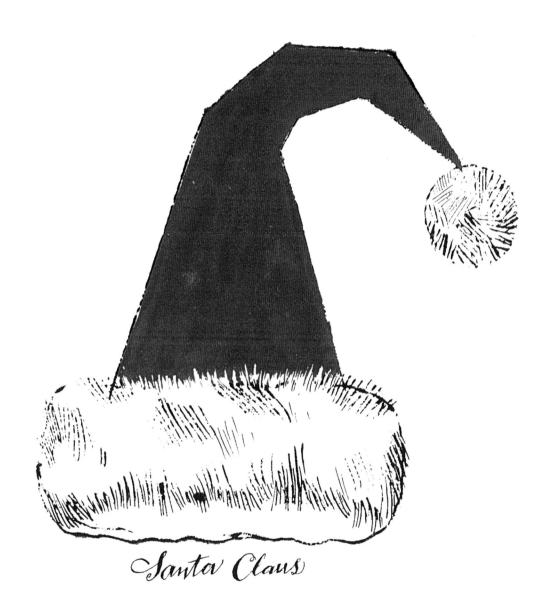

Santa Claus

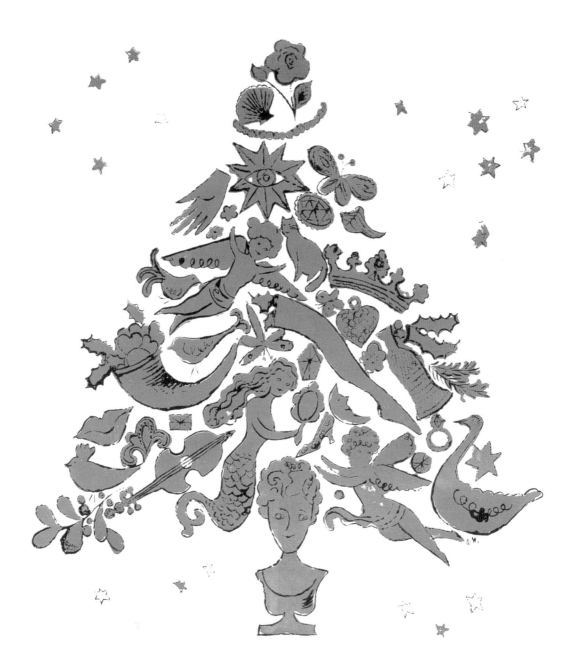

"And at Christmas time I really think about my mother . . ."

The Andy Warhol Diaries, December 27, 1985

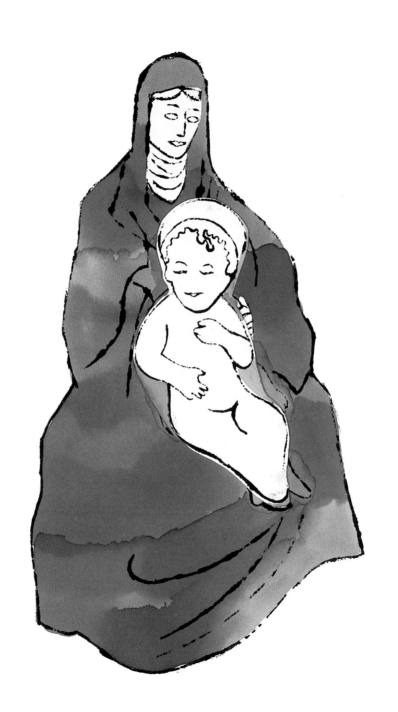

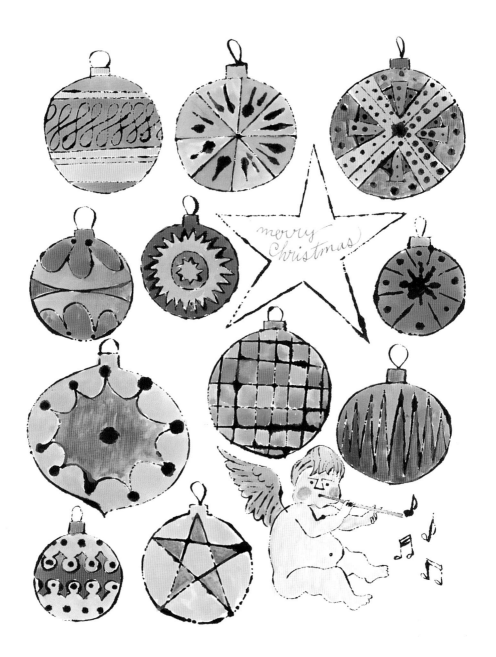

merry Christmas

"Everything was great, though, it was the best turkey and everything was fresh, the peas and everything, so I porked it up."

The Andy Warhol Diaries, December 24, 1980

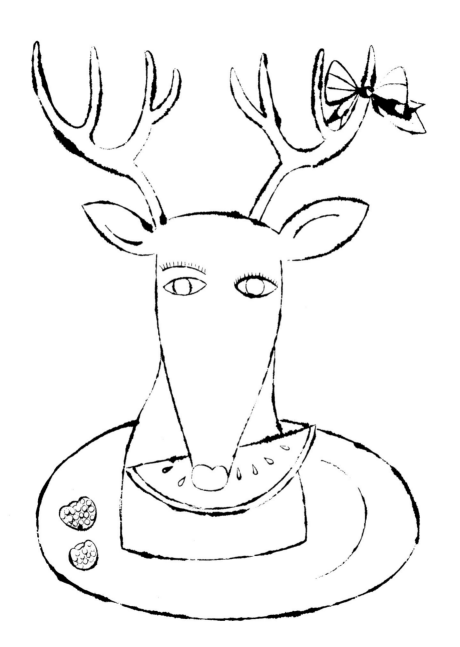

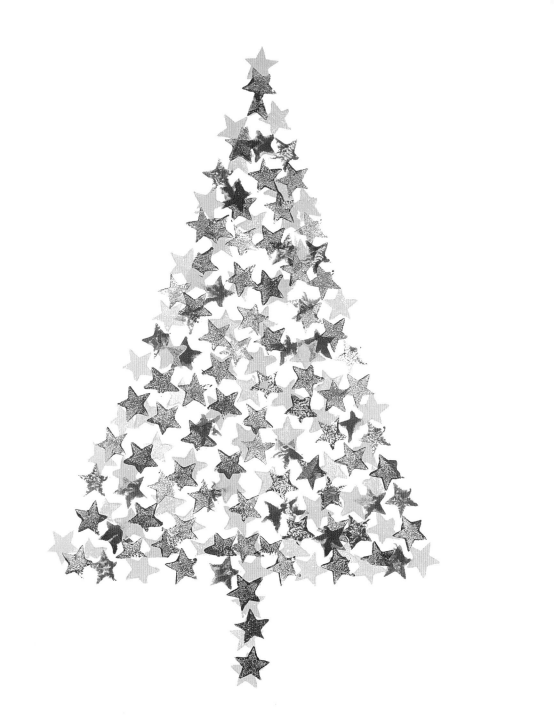

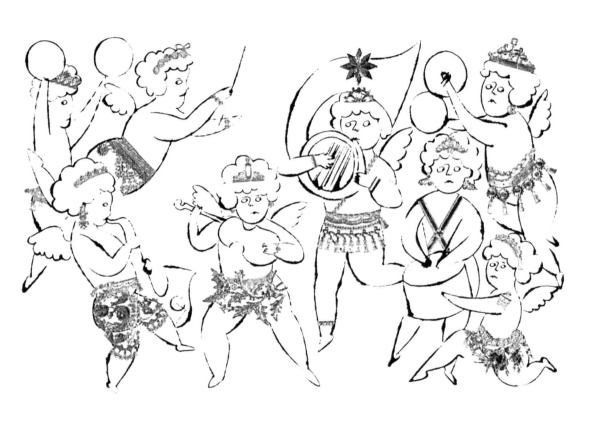

"It was a magazine Christmas—the decorations and the food and the house were just like a spread in *McCall's* or *House and Garden*, like what a house should look like on Christmas.**"**

The Andy Warhol Diaries, December 25, 1976

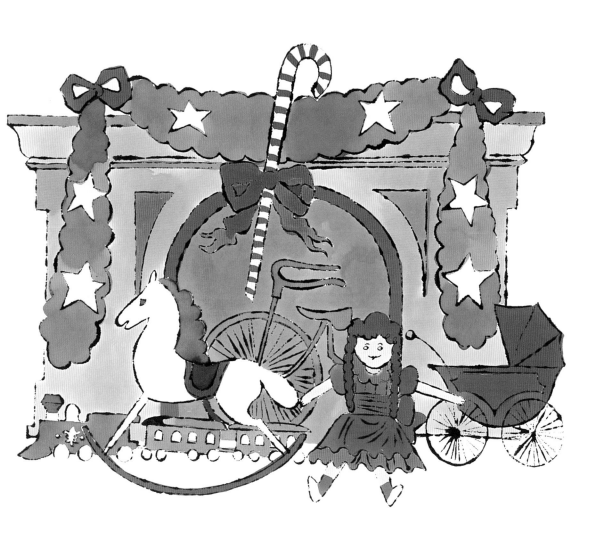

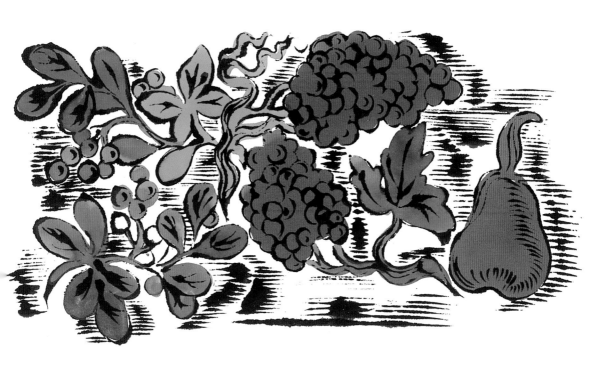

66The pies were great—apple, mince, and plum. The turkey had already been cut up like a magazine would tell you to before it got to the table, so it was like a Turkey Puzzle.99

The Andy Warhol Diaries, December 25, 1976

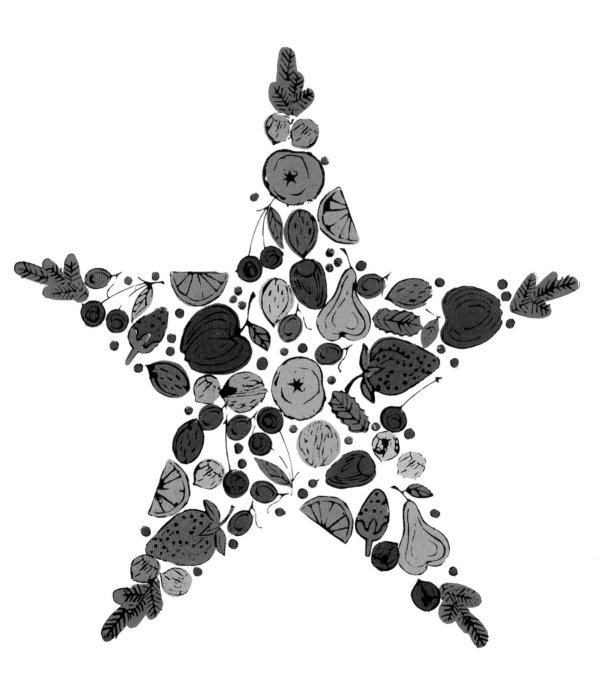

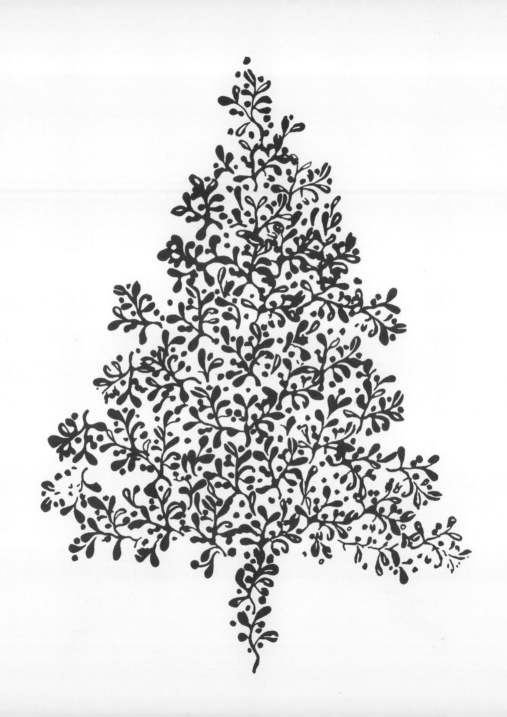

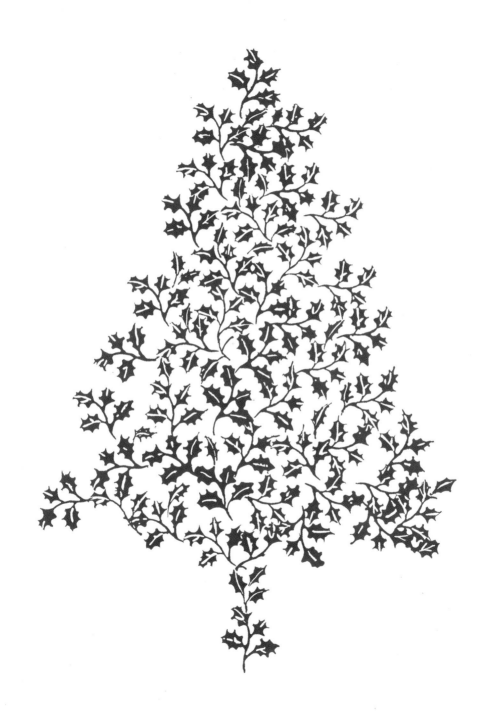

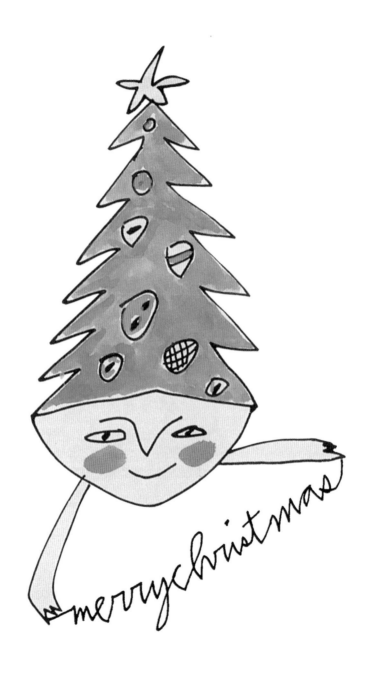

"Then we all did go to Studio 54. They had decorated it great, put silver glitter on the floor, and they had someone on a trapeze, and white balloons. . . ."

The Andy Warhol Diaries, December 31, 1978

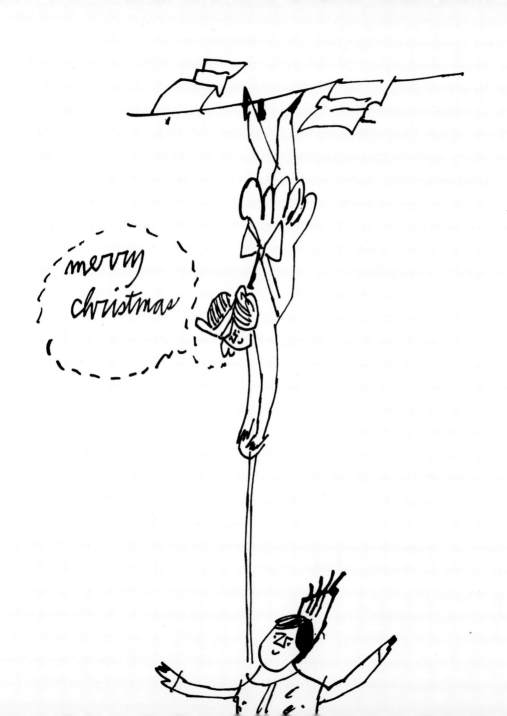

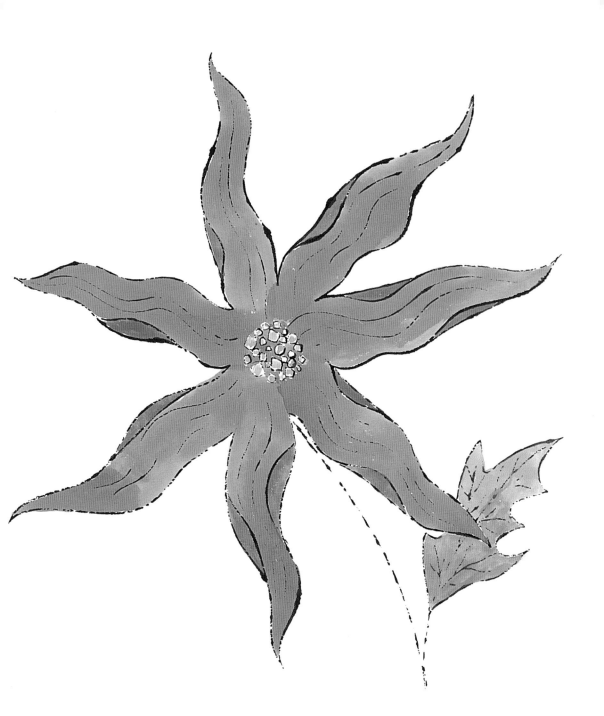

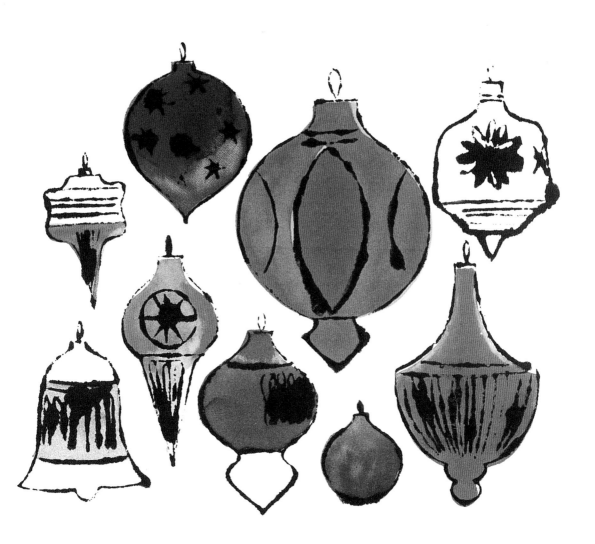

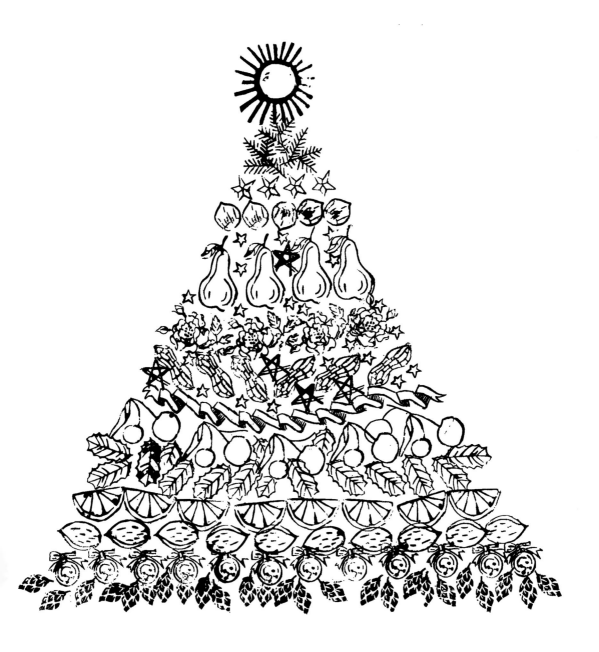

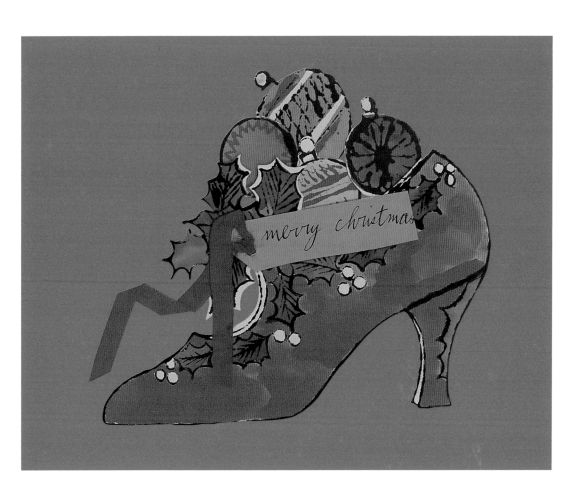

66 And oh, I love my *Enquirer* gift subscription that someone gave me for Christmas. Everything they say is true. 99

The Andy Warhol Diaries, March 29, 1983

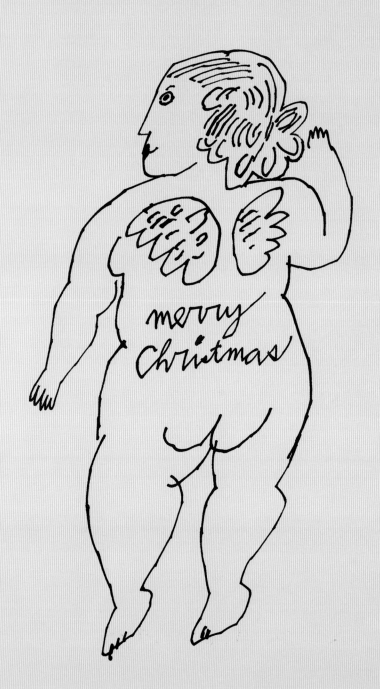

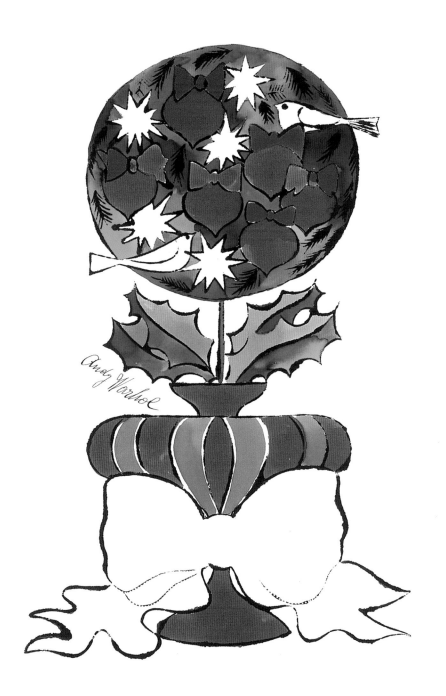

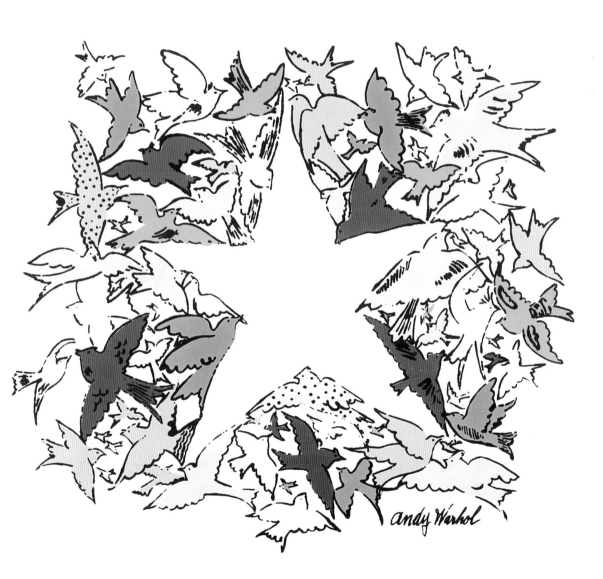

andy Warhol

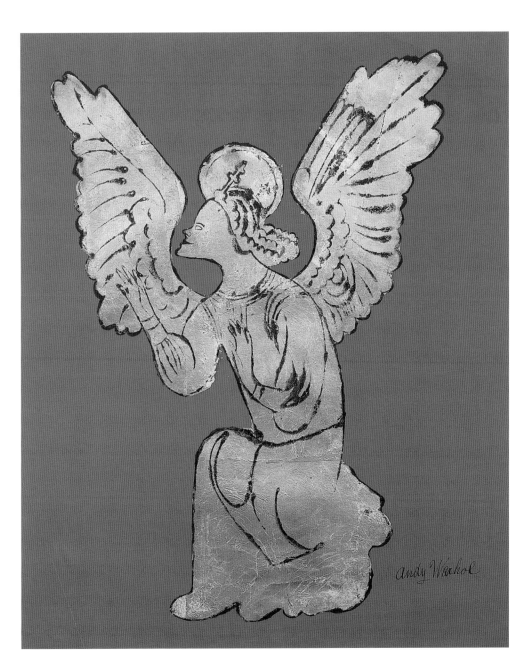

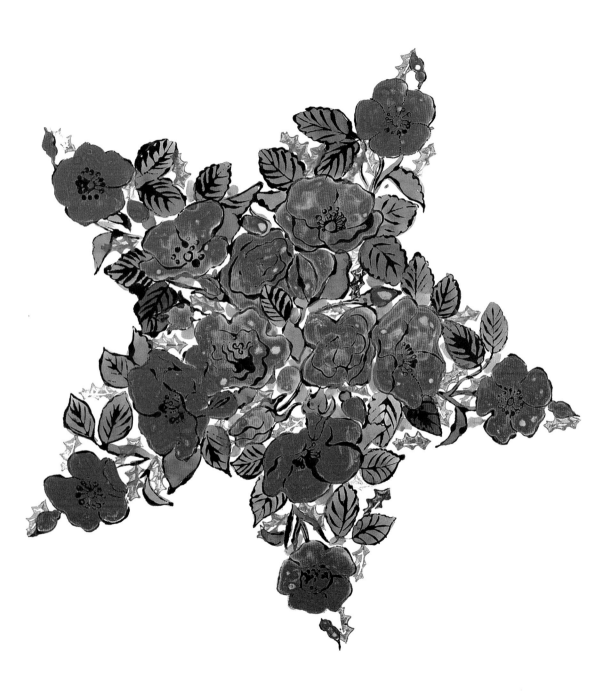

89 christmas fairies
wish
a merry christmas!

The Andy Warhol Diaries, December 25, 1980

Merry, Merry!
...andy Warhol

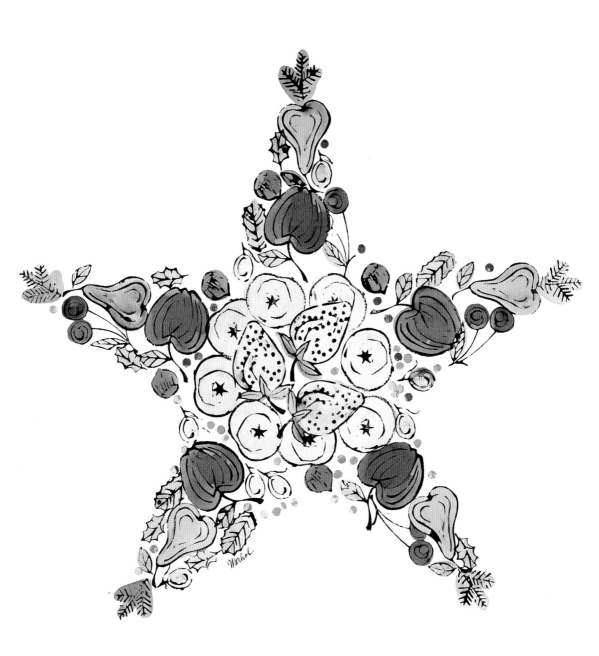

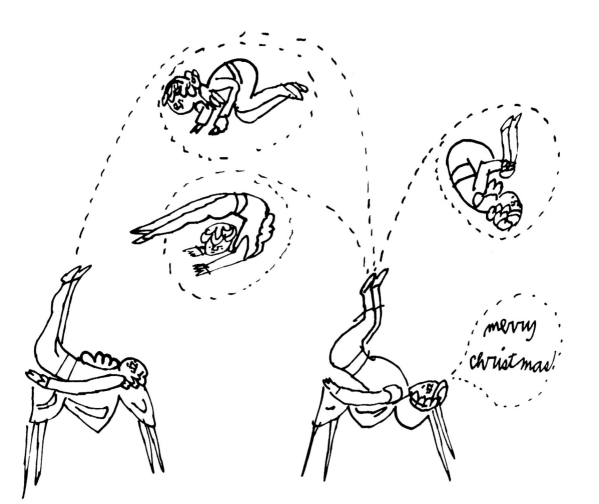

"The day after Christmas, and I was doing Christmas cards for next year for John Loring at Tiffany's."

The Andy Warhol Diaries, December 26, 1980

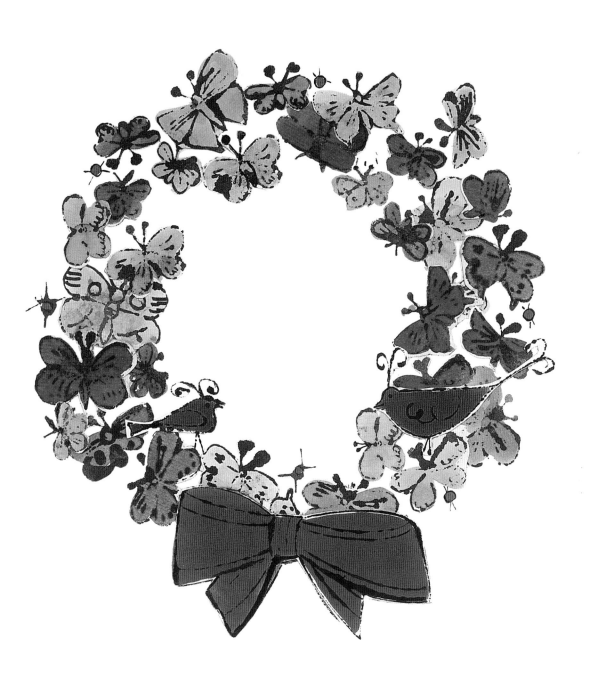

Captions

1. *Winged Fairy,* c. 1956
Gold leaf, ink, and stamped gold
collage on Strathmore paper
23 x 14¼ inches

3. *Untitled,* 1957
Ink and tempera on Strathmore
paper
12⅜ x 7¾ inches

4. *Christmas Card Design for
Tiffany & Co.,* c. 1957
Ink and Dr. Martin's Aniline Dye
on Strathmore paper
22½ x 14¼ inches

6. *Ornamented Christmas Tree,* 1960
Gouache, Day-Glo, and gold paint on
white paper
17¼ x 13 inches
Tiffany & Co. Archives

7. *"Parties! Parties! Parties!"* 1950s
Ink and Dr. Martin's Aniline Dye on
Strathmore paper
8 x 22⅝ inches

9. *Christmas Fairy,* c. 1954
Ink on tan paper
11⅞ x 9 inches

11. *Boot,* c. 1955
Ink and Dr. Martin's Aniline Dye on
Strathmore paper
14 x 11⅜ inches

12-13. *"Merry Christmas" with
Children,* c. 1955
Ink on white paper
15½ x 35½ inches
Tiffany & Co. Archives

14. *Madonna and Child*, 1950s
Gold leaf, ink, stamped gold collage,
and Dr. Martin's Aniline Dye on
paper
29 x 22 ⅞ inches

15. *Angels and Wreath*, c. 1958
Watercolor, gold leaf, and Dr.
Martin's Aniline Dye on
Strathmore paper
13½ x 18 inches
Tiffany & Co. Archives

17. *Christmas Basket*, 1962
Ink and gouache on Strathmore
paper
30 x 24 inches
Tiffany & Co. Archives

19. *Untitled*, c. 1958
Ink and Dr. Martin's Aniline Dye
on Strathmore paper
22½ x 16¾ inches

21. *Holly Shoe*, c. 1955-58
Offset lithograph and watercolor
on paper

23. *Ornament Tree*, c. 1960
Ink and gouache with applied paper
lace, a sequin, and silver foil stars,
rosettes, and swags on white paper
14⅞ x 11½ inches
Tiffany & Co. Archives

25. Study for *Star of Wonder*, 1960
Ink and gouache on Strathmore
Seconds paper
23½ x 29 inches
Tiffany & Co. Archives

27. *Sleigh with Gifts*, 1959
Watercolor, gouache, Day-Glo,
ink and Dr. Martin's Aniline Dye
on Strathmore paper
21½ x 14¾ inches
Tiffany & Co. Archives

 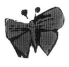 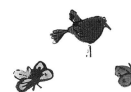 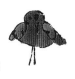 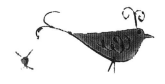

29. *Christmas Tree,* 1950s
Ink and Dr. Martin's Aniline Dye
on Strathmore paper
29 x 23 inches

31. *Monkey,* 1950s
Ink and Dr. Martin's Aniline Dye
on Strathmore paper
15½ x 11½ inches

33. *"Santa Claus,"* c. 1958
Ink and Dr. Martin's Aniline Dye
on Strathmore paper
7⅝ x 6¾ inches

35. *Bodley Gallery Announcement,*
1957
Offset lithograph on paper
12⅞ x 19½ inches

37. *Madonna and Child,* 1950s
Ink, Dr. Martin's Aniline Dye, and
collage on Strathmore paper
12¾ x 11½ inches

39. *Fairy and Christmas Ornaments,*
c. 1953-55
Graphite, ink, and Dr. Martin's
Aniline Dye on Strathmore paper
22½ x 14½ inches

41. *Reindeer* (from *Wild Raspberries:
A Book by Andy Warhol and Suzie
Frankfurt),* 1959
Ink on Strathmore paper
23 x 28⅞ inches

43. *Tree of Stars,* 1961
Stamped gouache and watercolor on
white paper
24 x 15¼ inches
Tiffany & Co. Archives

45. *Fairies Playing Instruments,*
c. 1957
Stamped gold collage and ink on
Strathmore paper
22½ x 28½ inches

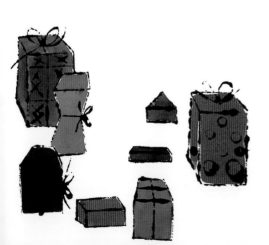

47. *Untitled,* 1950s
Ink and Dr. Martin's Aniline Dye
on Strathmore paper
12⅝ x 17¼ inches

49. *Still-Life,* 1950s
Ink and Dr. Martin's Aniline Dye
on Strathmore paper
12¼ x 14⅜ inches

51. *Holly and Fruit Star,* 1962
Offset lithograph on heavy paper
5½ x 5½ inches

52. *Mistletoe Tree* for the *Silver Trees*
Christmas card, 1962
Silver-engraved on light blue double-
folded paper
6½ x 5 inches
Tiffany & Co. Archives

53. *Holly Tree* for the *Silver Trees*
Christmas card, 1962
Ink on tracing paper
18¾ x 11 inches
Tiffany & Co. Archives

55. *Sprite With Christmas Hat,*
c. 1953-54
Ink and tempera on manila bond
paper
11 x 8½ inches

57. *Two Acrobats "Merry Christmas,"*
1950s
Ink on white bond paper
11 x 8½ inches

59. *Still-Life Flower,* 1950s
Ink and Dr. Martin's Aniline Dye
on Strathmore paper
22½ x 14¼ inches

61. *Tree Ornaments,* 1950s
Offset lithograph on card stock
4⅜ x 5¾ inches

63. Study for *Fruit and Nut
Christmas Tree,* c. 1950s
Ink on Strathmore paper
28⅝ x 17¼ inches
Tiffany & Co. Archives

65. *Merry Christmas Shoe,* c. 1957
Ink and Dr. Martin's Aniline Dye
on Strathmore and gold paper
9⅛ x 12½ inches

67. *Christmas Fairy,* c. 1954
Ink on white bond paper
11 x 8½ inches

69. *Christmas Topiary,* 1950s
Ink and Dr. Martin's Aniline Dye on
Strathmore paper
22⅝ x 14⅜ inches

71. *Star of Wonder,* 1960
Offset lithograph on card stock
5 x 6⅜ inches

73. *Angel,* c. 1957
Gold leaf and ink on colored graphic
art paper
20 x 15⅞ inches

75. *Star of Roses and Holly,* 1950s
Gouache on Strathmore Seconds
paper
23⅜ x 29½ inches
Tiffany & Co. Archives

77. *Christmas Fairy,* c. 1954
Ink on tan paper
10¾ x 9⅛ inches

79. *Winged Figures and Fashion
Accessories,* 1950s
Ink and Dr. Martin's Aniline Dye
on Strathmore paper
17¼ x 22½ inches

81. *Christmas Grid,* 1950s
Ink and Dr. Martin's Aniline Dye on
Strathmore paper
23 x 14¼ inches

83. *Holly and Fruit Star,* 1962
Ink and gouache on Strathmore
paper
30 x 23⅞ inches
Tiffany & Co. Archives

85. *Five Acrobats "Merry Christmas,"*
c. 1952
Ink on white bond paper
8½ x 11 inches

87. *Christmas Card Design for
Tiffany & Co.,* 1950s
Ink, Dr. Martin's Aniline Dye, and
printed material on Strathmore
paper
16⅜ x 12¼ inches

89. Detail of page 87

90–91. *Gift Packages,* c. 1954
Ink and Dr. Martin's Aniline Dye
on Strathmore paper
12½ x 11½ inches
(one illustration split in two parts)

94. *Christmas Roses and Bird,* 1950s
Ink and Dr. Martin's Aniline Dye on
Strathmore paper
23 x 14³/₄ inches

95. *Sprite Heads Over "Merry,"* 1950s
Ink on Strathmore paper
3¹/₈ x 10¹/₄ inches

96. *Fir Tree,* 1950s
Ink on acetate on Strathmore paper
20 x 11 inches

Jacket, front flap: Detail of *Bird and
Ornament,* c. 1957
Ink and Dr. Martin's Aniline Dye on
collage on board
11¹/₄ x 10¹/₈ inches

Jacket, back flap: *Bird and
Ornament,* c. 1958
Ink and Dr. Martin's Aniline Dye on
Strathmore paper
14¹/₈ x 12⁷/₈ inches

Front endpaper: *Candy Cane and
Holly Leaves,* 1950s
Ink and acetate on Strathmore paper
4⁵/₈ x 3³/₈ inches

Back endpaper. *Snowflake,* 1950s
Ink on Strathmore paper
7¹/₂ x 6³/₈ inches

Bibliography

Hackett, Pat, ed. *The Andy Warhol Diaries.* New York: Warner Books, 1989.

Kornbluth, Jesse. *Pre-Pop Warhol.* New York: Random House, 1988, p. 41.

Moore, Gene and Jay Hyams. *My Time at Tiffany's.* New York: St. Martin's Press, 1990, p. 69.

Warhol, Andy. *The Philosophy of Andy Warhol.* New York: Harcourt Brace Jovanovich, Inc., 1975, pp. 22-23.

Acknowledg
ments

𝒯he author and Tiffany & Co. would like to thank all those who made *Greetings from Andy (Warhol)* a reality: Tiffany's chairman and chief executive officer Michael Kowalski; Tiffany's senior vice president of marketing, Caroline Naggiar; and Tiffany's senior vice president of public relations, Fernanda Kellogg, for their unbounded enthusiasm.

Special recognition must go to John Smith, assistant director of collections and research, and Greg Burchard, rights and reproductions photography services manager, both of the Andy Warhol Museum; Vincent Fremont of the Andy Warhol Foundation; the Artists Rights Society, especially rights administrator Maria Fernanda Meza, for their generosity in making so much of Andy Warhol's greeting card imagery available; Eric Erickson whose invaluable aesthetic judgments put the imagery back into publishable form; Rollins Maxwell for his help on assembling caption materials; MaryAnn Aurora for traffic control; Eric Himmel, editor in chief of Harry N. Abrams, for his enlightened ideas; Harriet Whelchel, managing editor, for her support; our editor, Andrea Danese, for her vision of the far-reaching charm and universal appeal of Andy Warhol's playful drawings; our designer, Ellen Nygaard Ford, for her splendid and vigorous imagination that makes *Greetings from Andy (Warhol)* a visual delight; and to Andy's "superstar," Ultra Violet, for her poetic preface to the book.

The author also owes eternal gratitude to the late art writers and intimates of Andy Warhol, Mario Amaya and David Bourdon, and to the cover illustrator of Andy's *Interview* magazine, the late Richard Bernstein, all once close friends of the author who introduced him to the so colorful world of Andy Warhol.

Finally, Tiffany & Co. is forever grateful to our magician of display, the late Gene Moore, who was one of the first, in the mid-1950s, to recognize the genius of Andy Warhol's art and the one to invite that genius to forever be part of Tiffany & Co.

EDITOR: Andrea Danese
DESIGNER: Ellen Nygaard Ford
PRODUCTION MANAGER: Maria Pia Gramaglia

Library of Congress Cataloging-in-Publication Data

Loring, John.
 Greetings from Andy : Christmas at Tiffany's / by John Loring ;
illustrations by Andy Warhol.
 p. cm.
 Includes bibliographical references.
 ISBN 0-8109-4962-8
 1. Warhol, Andy, 1928–-Themes, motives. 2. Christmas cards–
United States. 3. Tiffany and Company. I. Warhol, Andy, 1928- II.
Title.

 NC1868.W37A4 2004
 769.92–dc22

 2004011844

Text and illustrations from Tiffany & Co. Archives
copyright © 2004 Tiffany & Co.
All other illustrations copyright © 2004 Andy Warhol Foundation
for the Visual Arts/ARS, New York
Excerpts from *The Andy Warhol Diaries* by Pat Hackett
copyright © 1989 by The Estate of Andy Warhol. By permission of
Warner Books, Inc.

Published in 2004 by Harry N. Abrams, Incorporated, New York.

Printed and bound in China

10 9 8 7 6 5 4 3 2 1

Harry N. Abrams, Inc.
100 Fifth Avenue
New York, N.Y. 10011
www.abramsbooks.com

Abrams is a subsidiary of

LA MARTINIÈRE

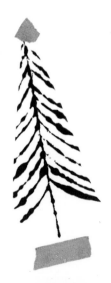

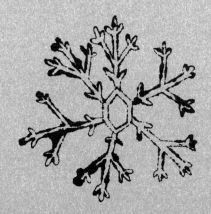